Reflections of Light

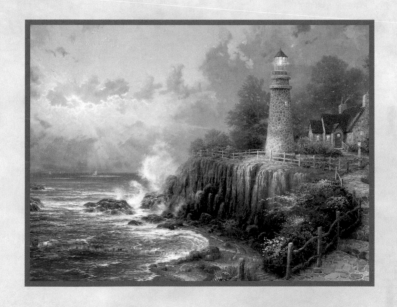

BY THOMAS KINKADE

THOMAS KINKADE

Painter of Light

He will make your righteousness
shine like the dawn

PSALMS 37:6

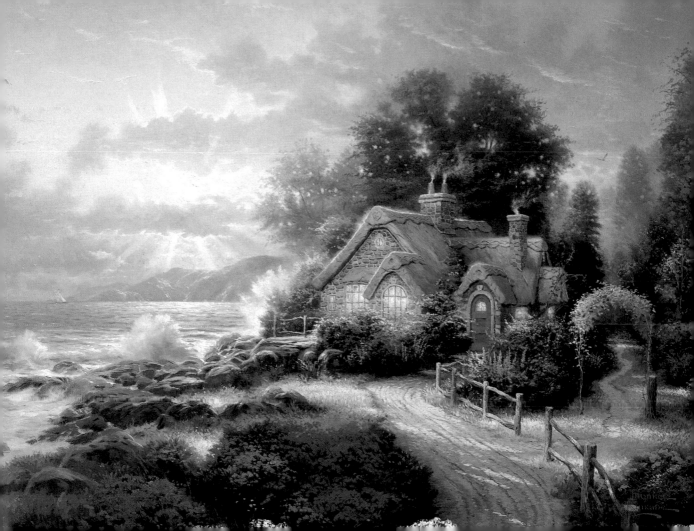

*Come, follow me, and I will
make you fishers of men*

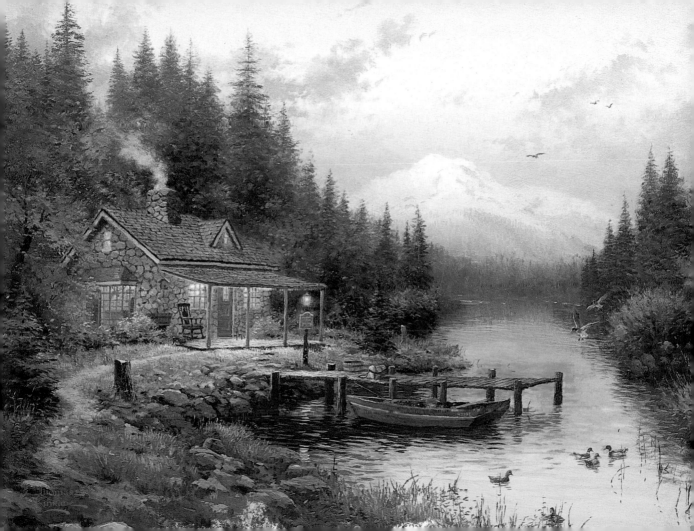

I am the light of the world.
Whoever follows me will never walk in
darkness, but will have the light of life

JOHN 8:12

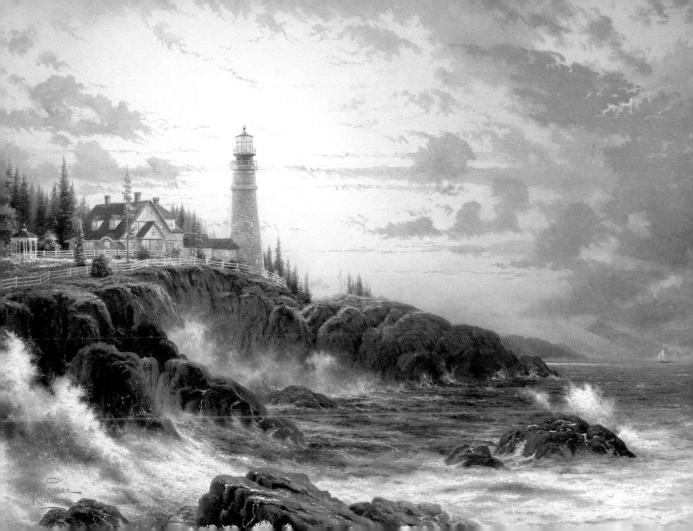

God is in me as the sun is in
the fragrance and color of a flower

HELEN KELLER

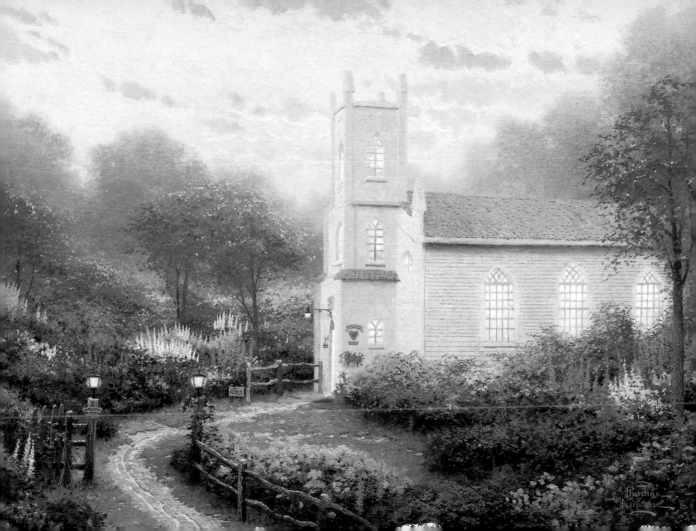

Two roads diverged in a wood, and I —
I took the one less traveled by,
and that has made all the difference

ROBERT FROST

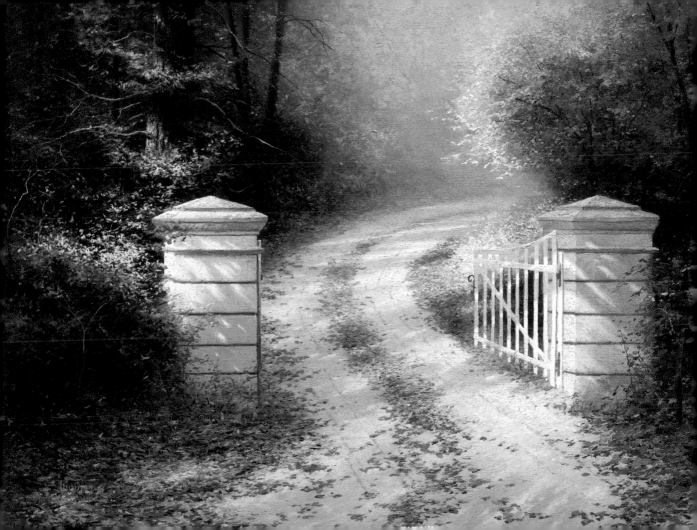

But as for me and my household,
we will serve the Lord

JOSHUA 24:18

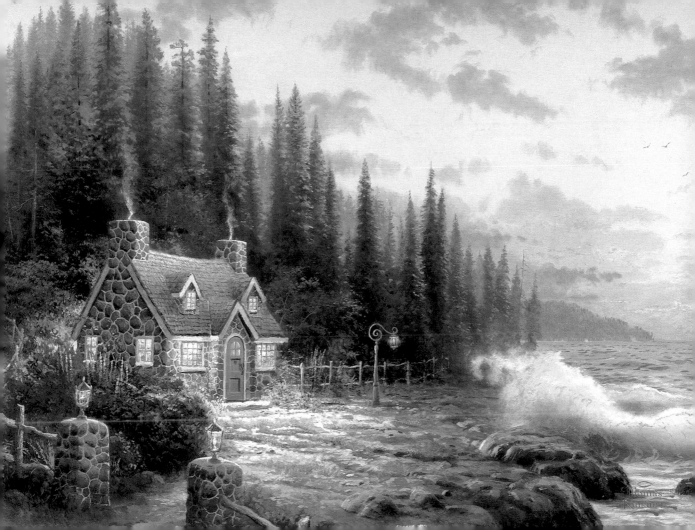

All nature smiles, and the whole world is pleased

DAY KELLOGG LEE

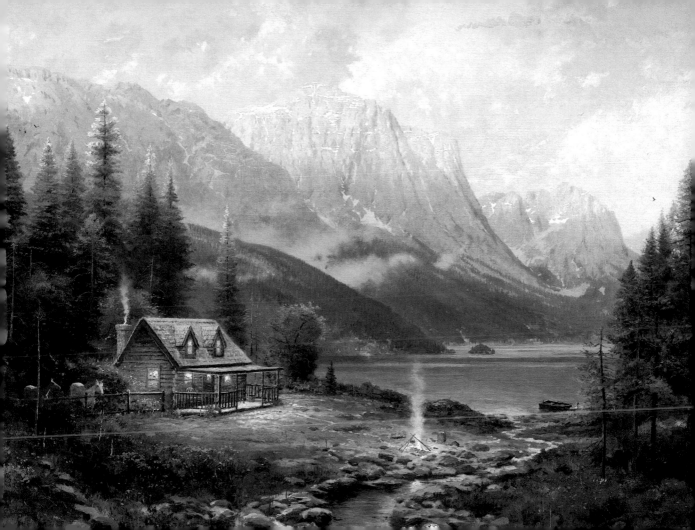

I am the way and the truth and the life.
No one comes to the Father except through me

JOHN 14:6

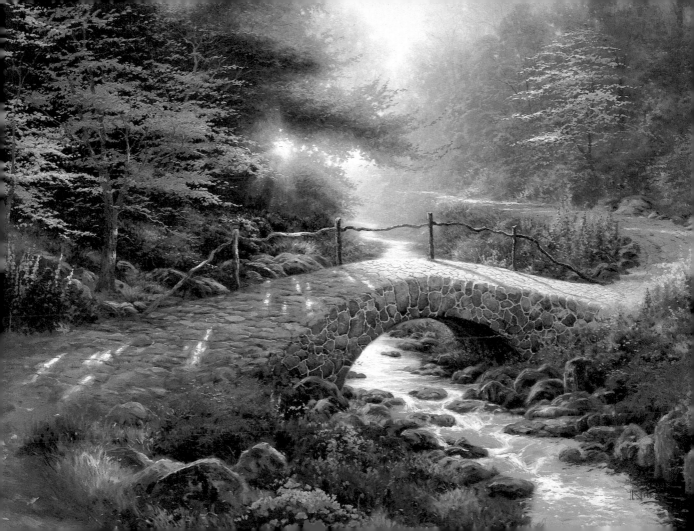

The heavens declare the glory of God;
the skies proclaim the work of his hands

PSALM 19:1

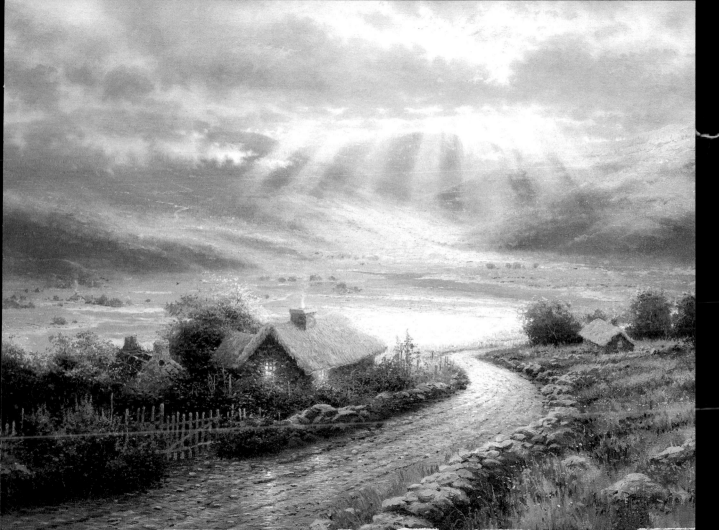

Let the heavens rejoice, and let the earth be glad...
Let the field be joyful and all that is therein:
then shall all the trees of the wood rejoice

THE BOOK OF PSALMS

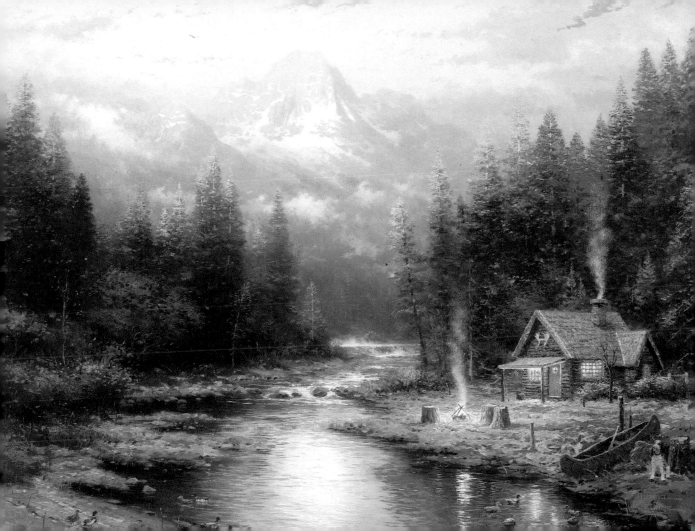

The Lord bless you and keep you;
the Lord make his face shine upon you and be
gracious to you; the Lord turn his face
toward you and give you peace

NUMBERS 6:24-26

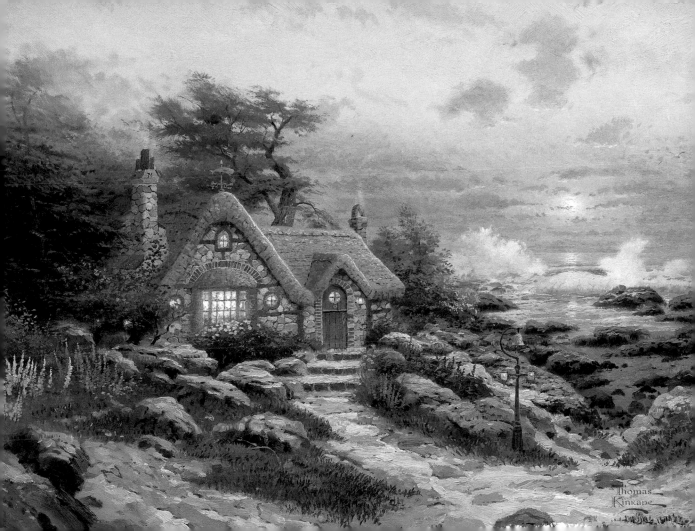

The Lord is my light and my salvation-
whom should I fear? The Lord is the stronghold
of my life- of whom shall I be afraid?

PSALM 27:1

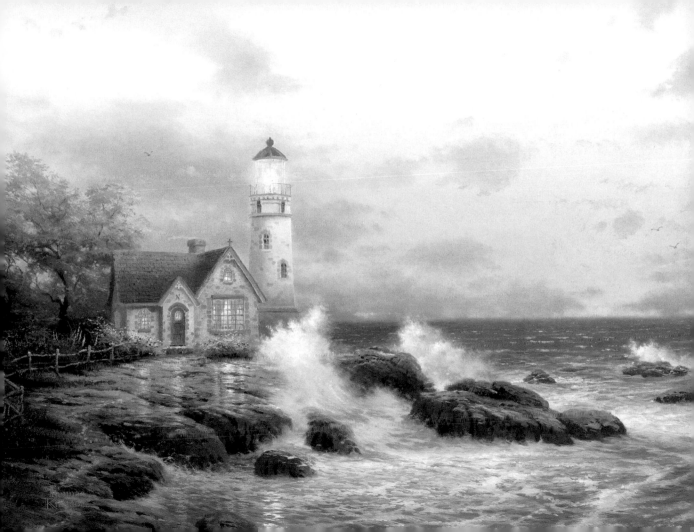

And in His will is our peace

DANTE

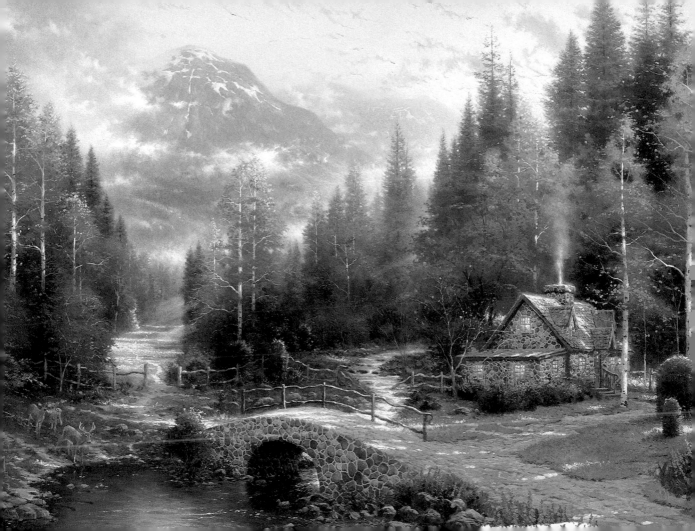

The Lord is faithful to all his promises
and loving towards all he has made

PSALMS 145:13

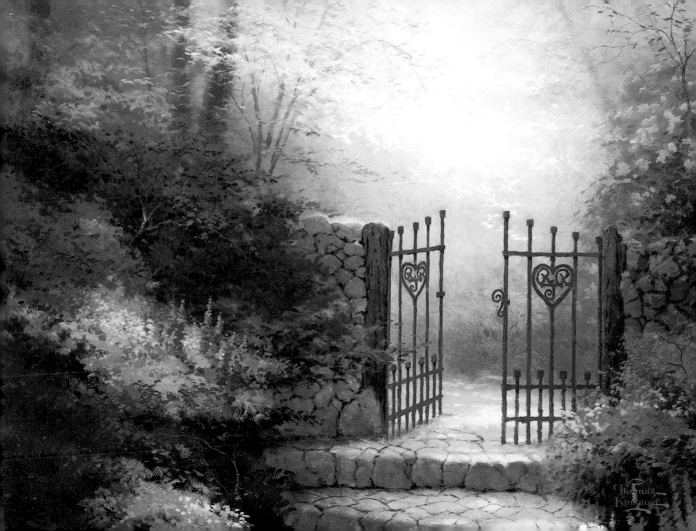

There is no music like a river's.
It quiets a man down like saying his prayers

ROBERT LOUIS STEVENSON

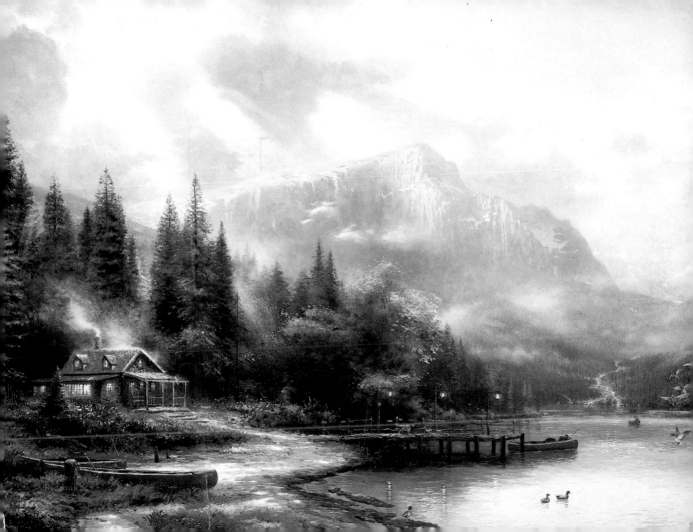

The light shines in the darkness

JOHN 1:5

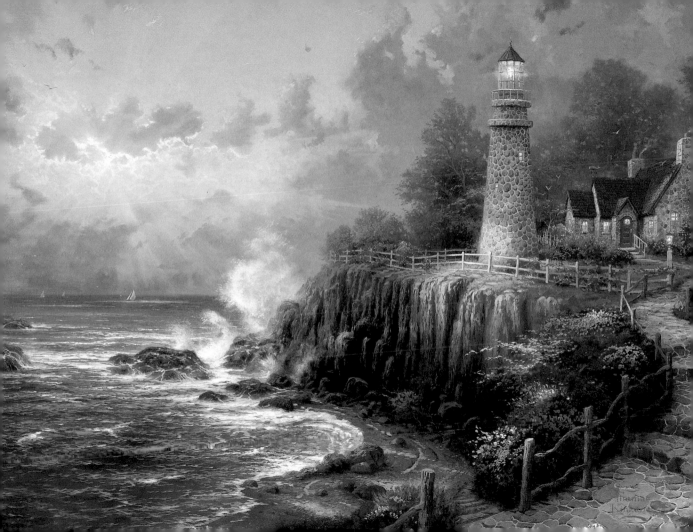

And this our life... find tongues in trees,
books in the running brooks, sermons in stones,
and good in everything

SHAKESPEARE

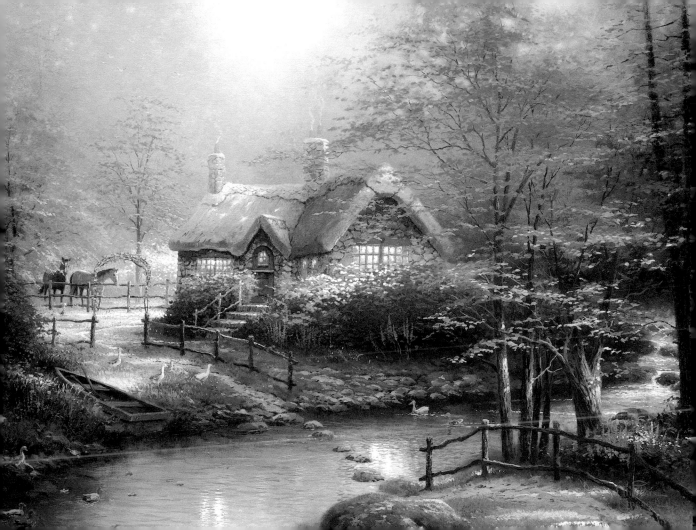

And now abide faith, hope, love, these three;
but the greatest of these is love

THE APOSTLE PAUL

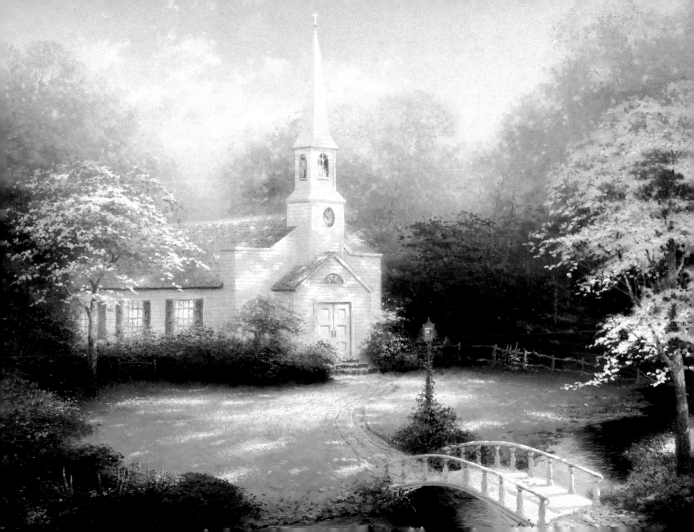

Be my rock of refuge, a strong fortress to save me.
Since you are my rock and my fortress for the sake
of your name lead and guide me

PSALM 31:3

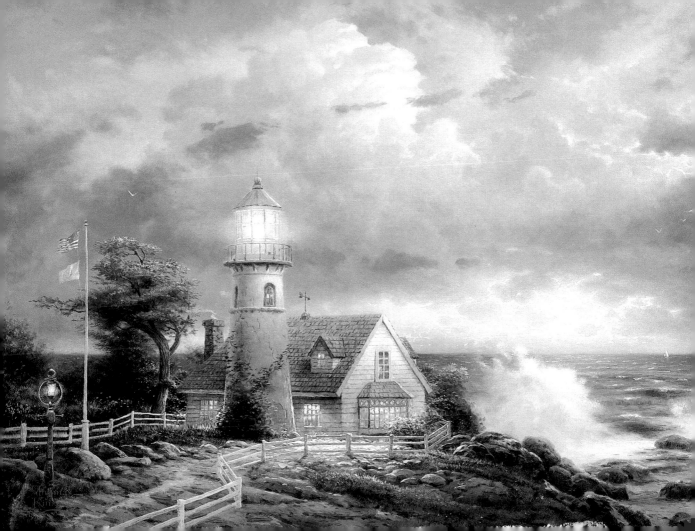

*When we come back to things that really
matter, then peace begins to settle into our lives
like golden sunlight sifting to a forest floor.
And somewhere deep down inside we know
that simpler times are better times*

THOMAS KINKADE

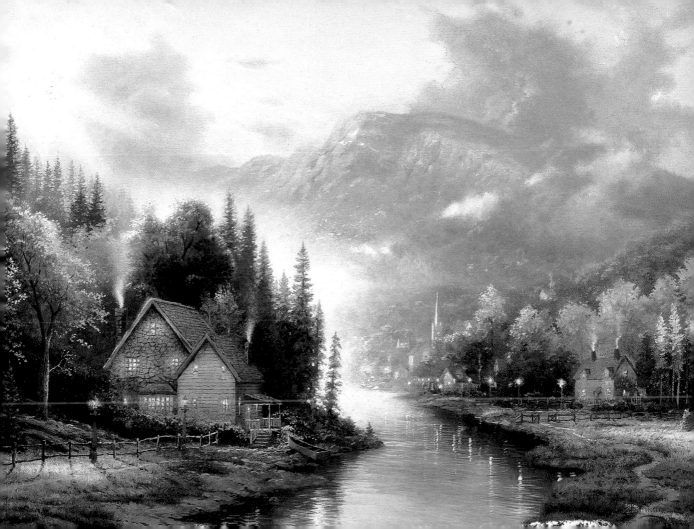

Thomas Kinkade, "The Painter of Light", is one of America's most collected artists. In the tradition of the 19th century American Luminists, Kinkade uses light to create romantic worlds that invite us in and evoke a sense of peace. Kinkade paints a wide variety of subjects, including cozy cottages, rustic outdoor scenes, dramatic landscapes, and bustling cities. Each painting radiates with the "Kinkade glow" that he attributes to "soft edges, a warm palette, and an overall sense of light."

Thomas Kinkade is a messenger of simplicity and serenity in these fast-paced turbulent times. His paintings are more than art, they are silent messengers of hope and peace that lift our spirits and touch our hearts.

Thomas Kinkade was born in Sacramento, California in 1958, raised in humble surroundings in the nearby town of Placerville. Kinkade apprenticed under Glen Wessels, an influential artist who had retired in the community. He later attended the University of California and received formal training at Art Center College of Design in Pasadena.

As a young man, Thomas Kinkade earned his living as a painter, selling his originals in galleries around California. He married his childhood sweetheart, Nanette, in 1982, and two years later they began to publish his art. In 1989 Lightpost Publishing was formed.

Thomas Kinkade is a devout Christian and credits the Lord for both the ability and the inspiration to create his paintings. His goal as an artist is to touch people of all faiths, to bring peace and joy into their lives through the images he creates. The letters he receives everyday testify to the fact that he is, at least at some level, achieving this goal.

A devoted husband and doting father to their four little girls, Kinkade always hides the letter "N" in his paintings to pay tribute to his wife, Nanette, and the girls often find their names and images tucked into the corners of his works.

"As an artist I create paintings that bring to life my inspirational thoughts and feelings of love, family and faith. I hope each image in my collection acts as a messenger of hope, joy and peace to you and your family."

Welcome to the Thomas Kinkade Collectors' Society

Dear Collector,

 Some painters would say that they work with pigment, others with color. I prefer to think that I paint with light. Surely, God paints His creation with light, and that inspires me. I hope you'll agree that there is a radiant quality to my paintings, as if it were lit from within.

 That effect is something members of the Thomas Kinkade Collectors' Society especially enjoy. So when I invite you to join us, I'm really urging you to let your light shine. With the help of Collectors' Society members, we'll illuminate a world of beauty and grace this year.

Thomas Kinkade

 By joining the Thomas Kinkade Collectors' Society, you will enter a world of beauty that only Thomas Kinkade can create. Your membership for 1998 will include a very special "Welcome Kit" and members-only benefits to last all year long. For information on how you can join the Thomas Kinkade Collectors' Society visit your local Authorized Dealer or call: 1 . 800 . 544 . 4890

Visit our Website at:
 www.thomaskinkade.com

1998 offers available
January 1, 1998 - December 31, 1998

Index of Works